Matthias Schaller

Controfacciata

Ben Brown Fine Arts | Steidl

Matthias Schaller's photographs are a magical art of magical places. He manages to imbue Venice with a new vision and a new angle despite it being arguably the most photographed and painted city in history. There is a melancholic yet optimistic side to his photographs of Venice which is balanced by his technical skill as a photographer.

The Controfacciata series is just one which Matthias Schaller has been working on recently. He has photographed opera houses in Italy, bedrooms in Naples and studios of famous architects and photographers.

Seeing spaces bereft of humans is highly symbolic for Matthias Schaller, serene and splendid. Piano, Gehry, Foster, Bernd and Hilla Becher, Ruff, Gursky and Struth, all are shown in the series of working studios and in their different way demonstrate their respect for him by allowing Matthias Schaller into their hallowed inner sanctum.

I want to thank Matthias Schaller for entrusting his first show in England to me and hope that the reception is deservedly warm. I also thank Jean Michel Wilmotte, Lia Rumma, Elisabetta Cipriani, Richard Dyer and Peter Willberg, all the team in my gallery, the team at Steidl.

BEN BROWN

to Giulia with Olympia

I

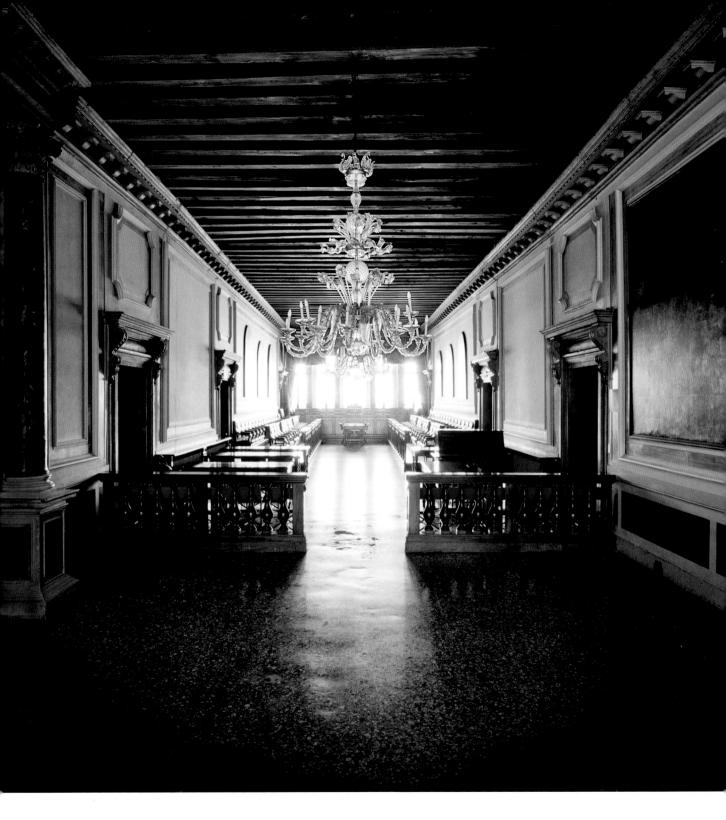

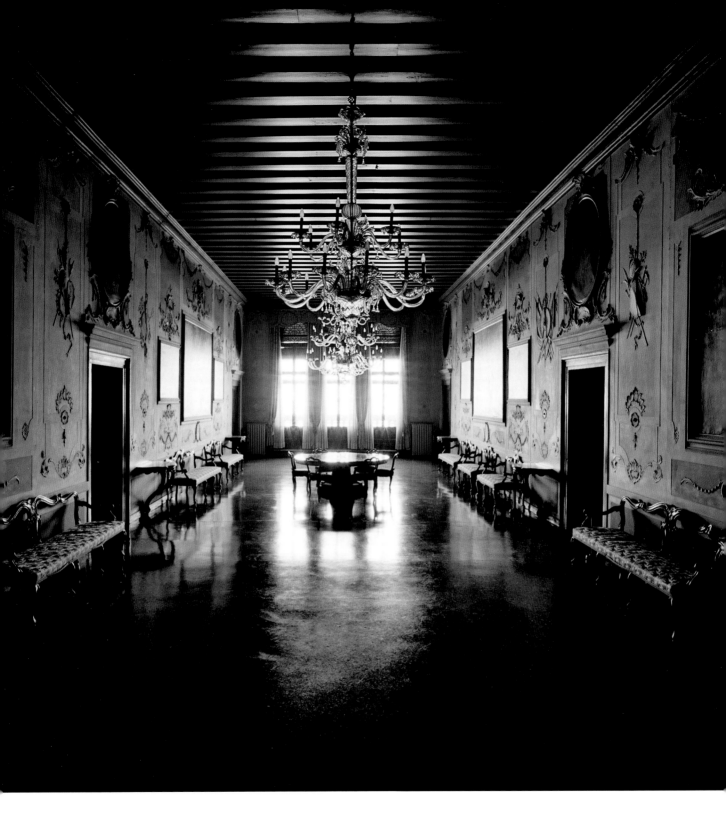

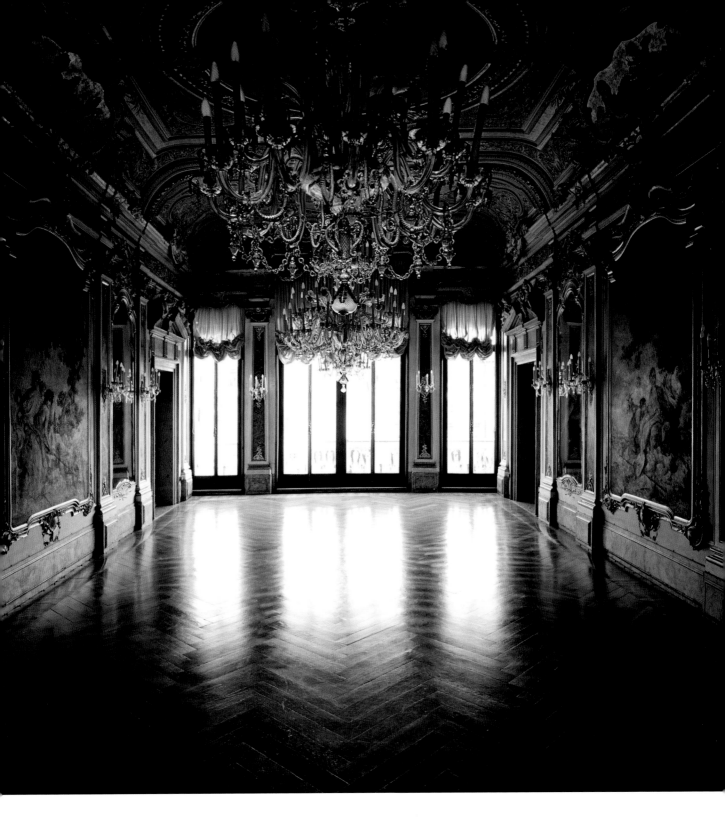

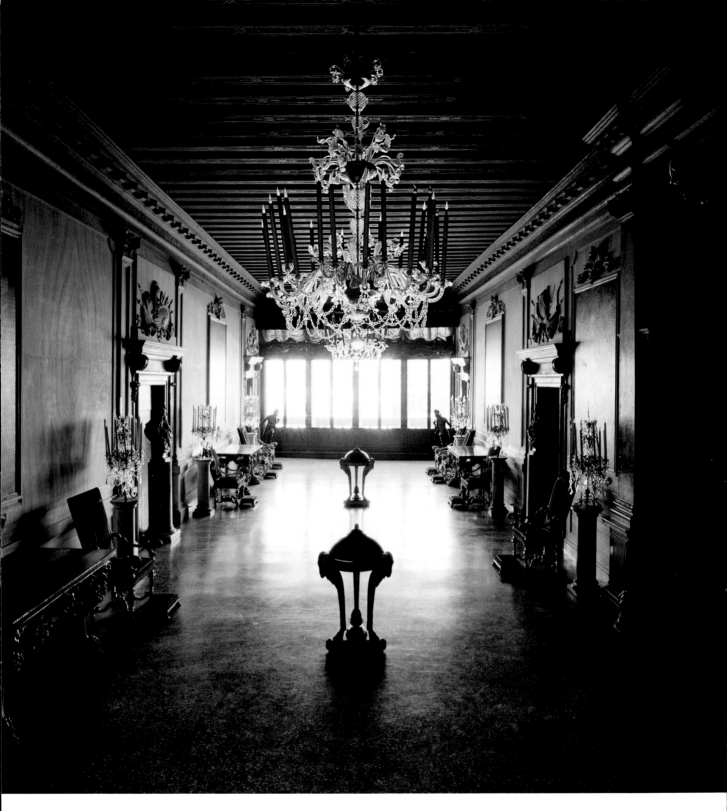

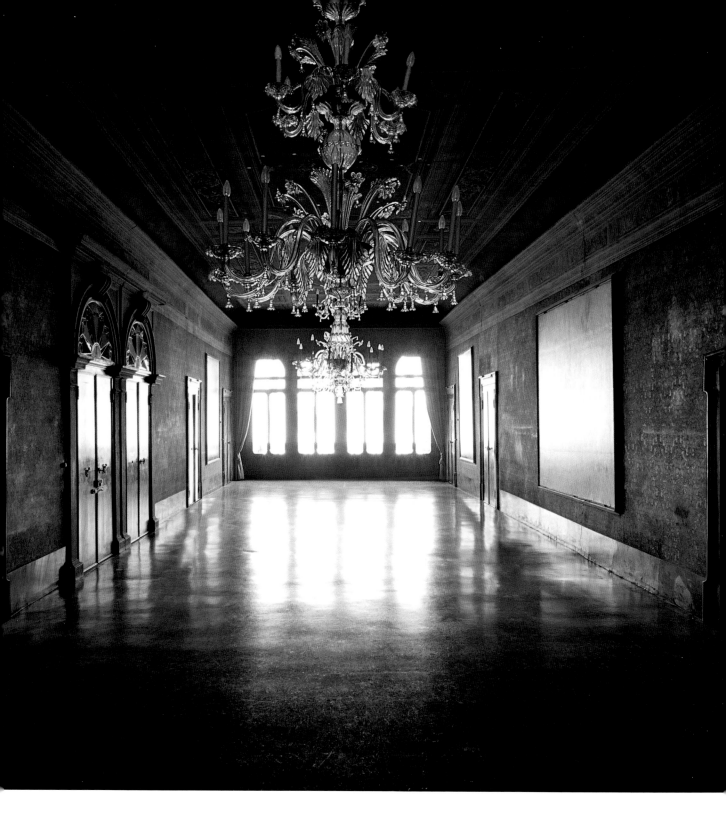

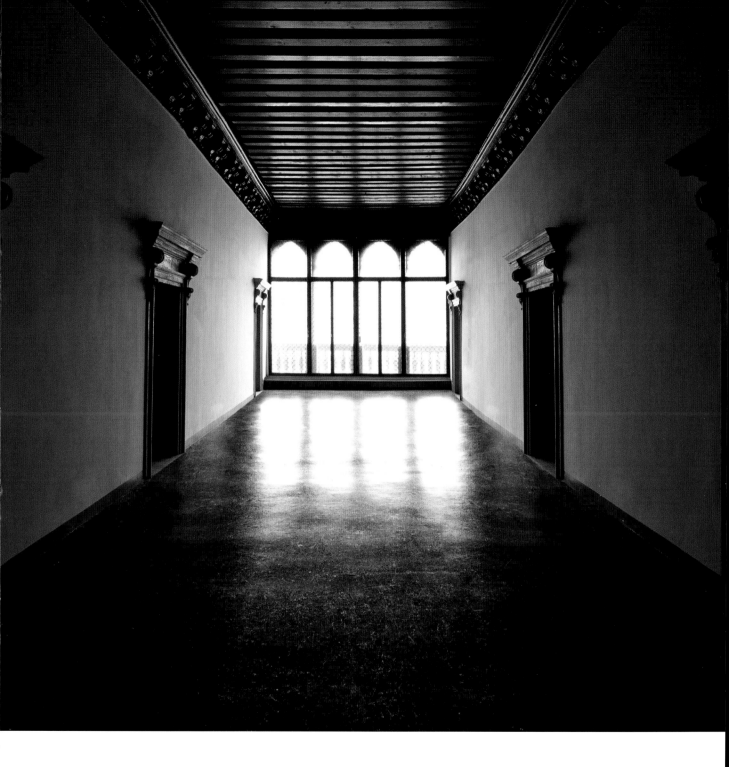

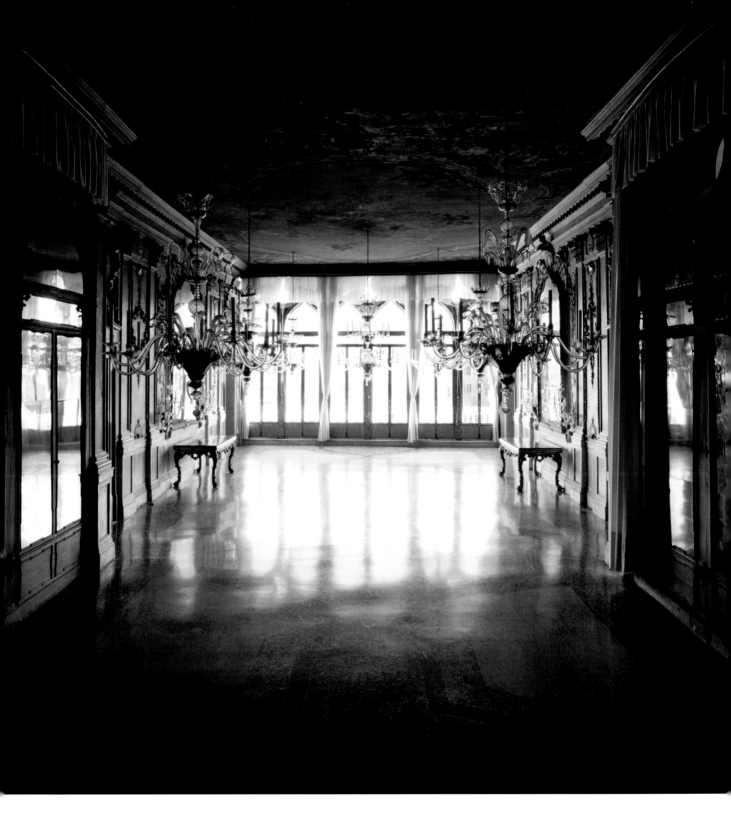

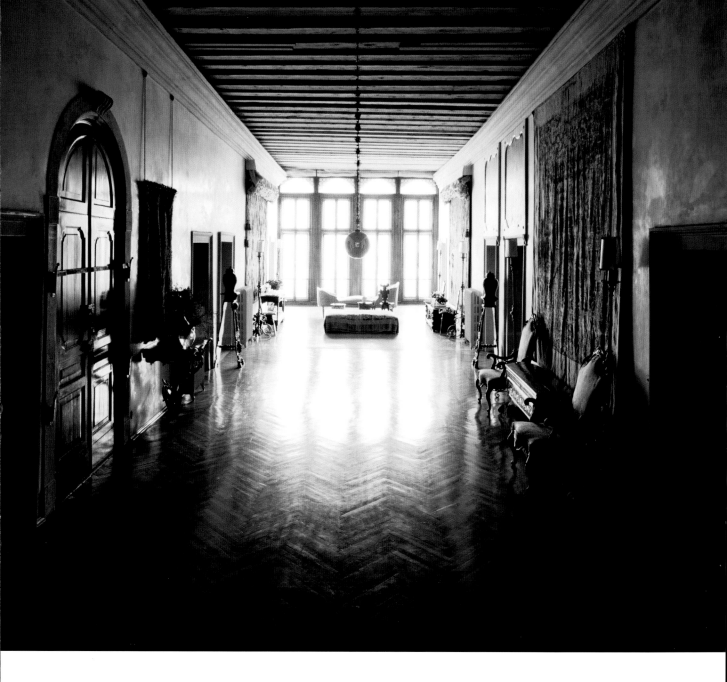

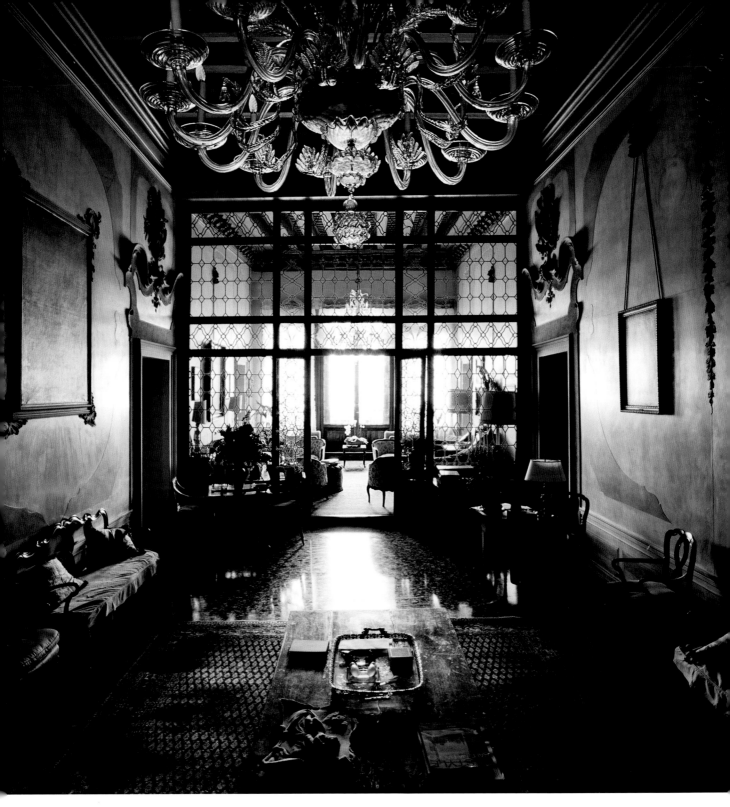

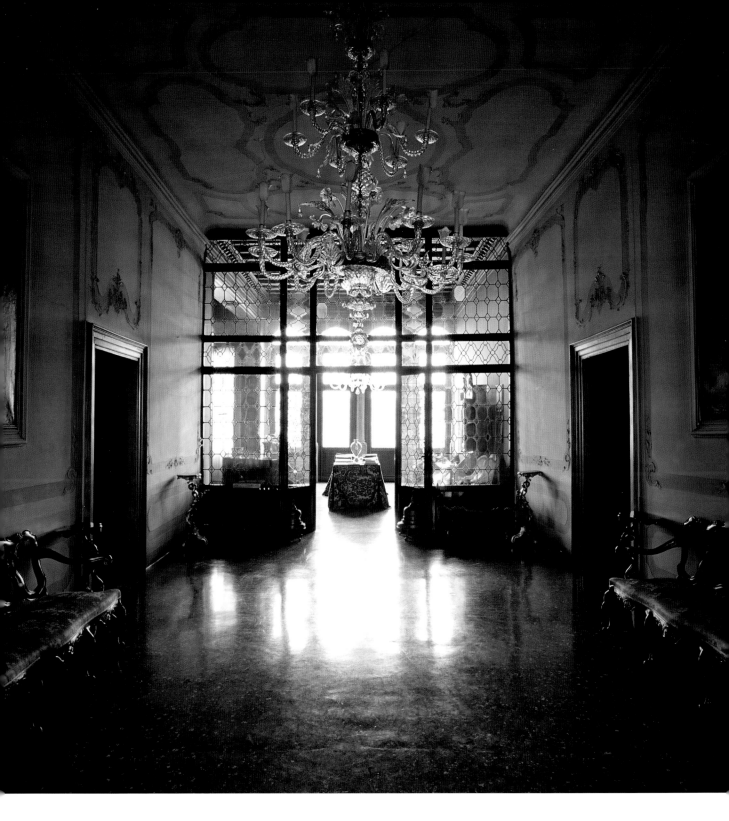

II

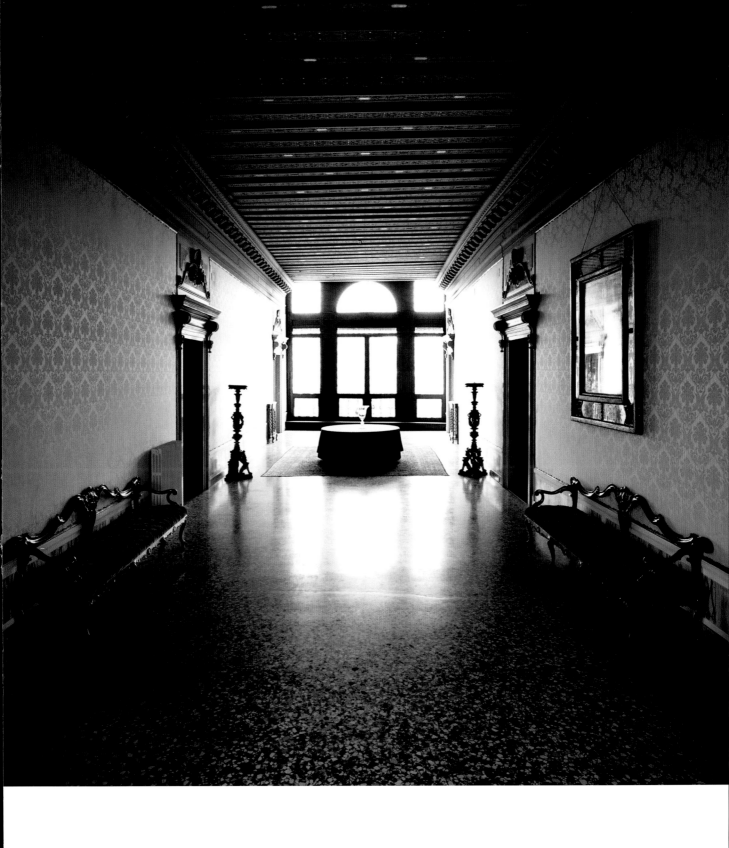

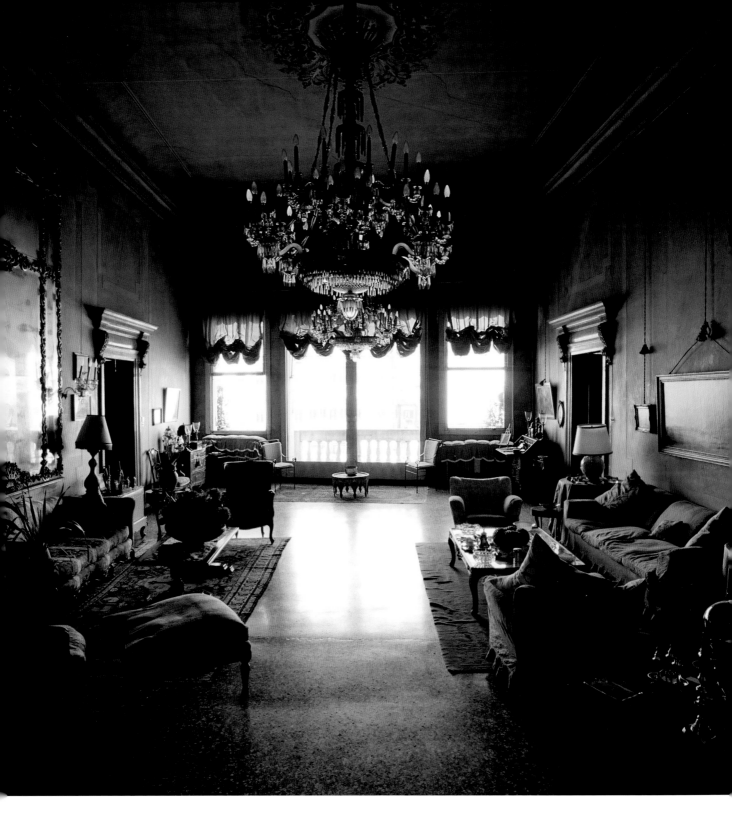

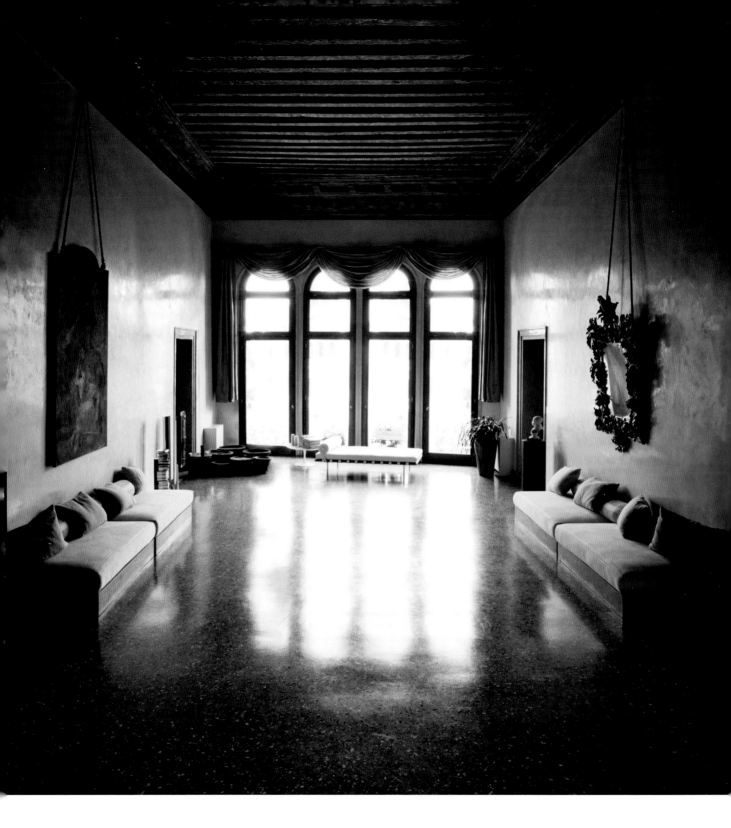

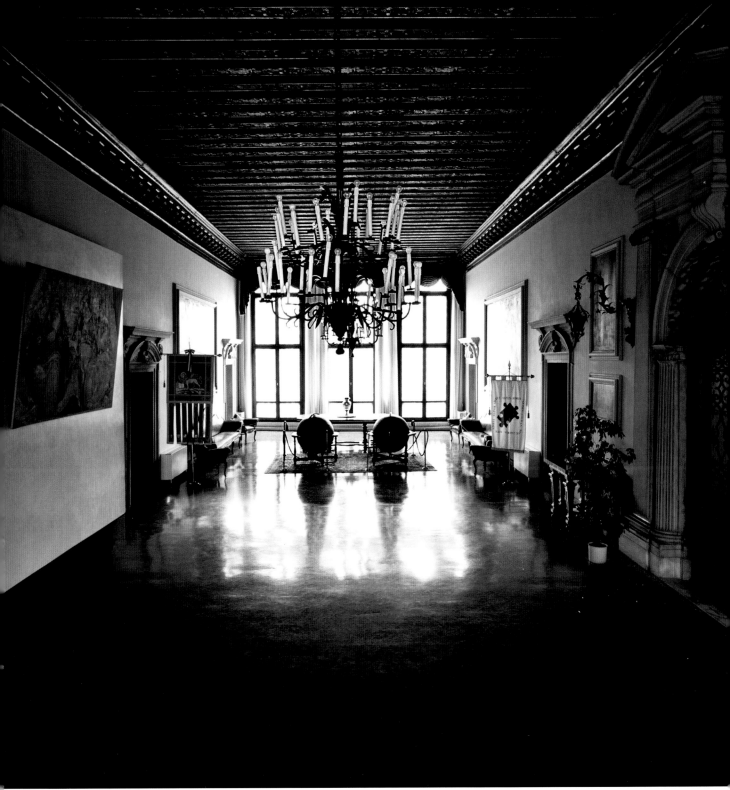

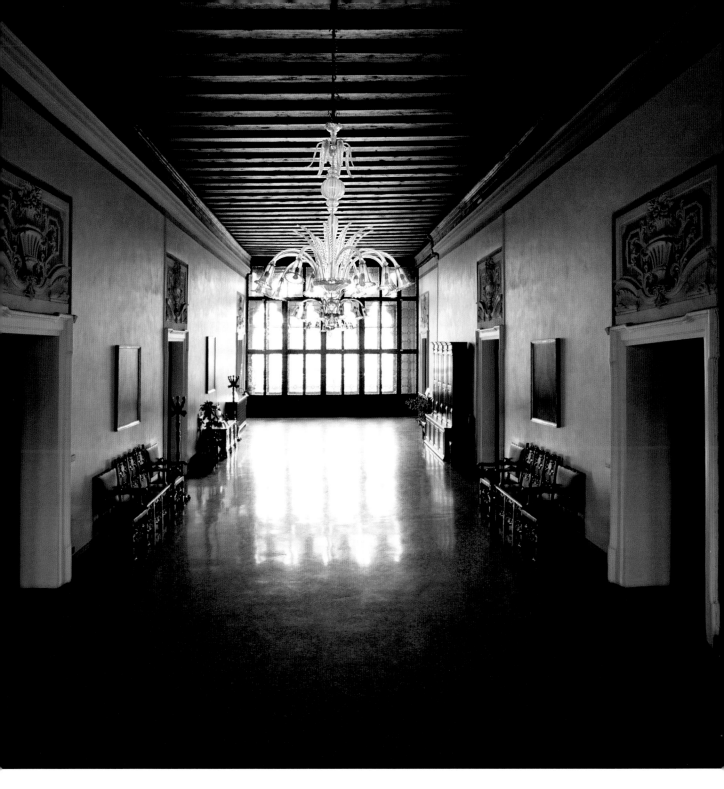

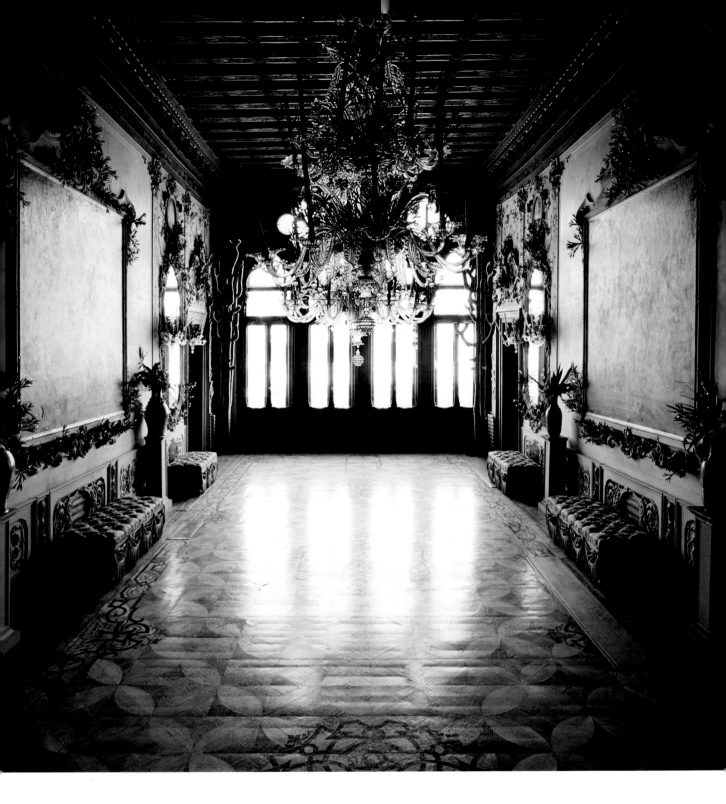

17

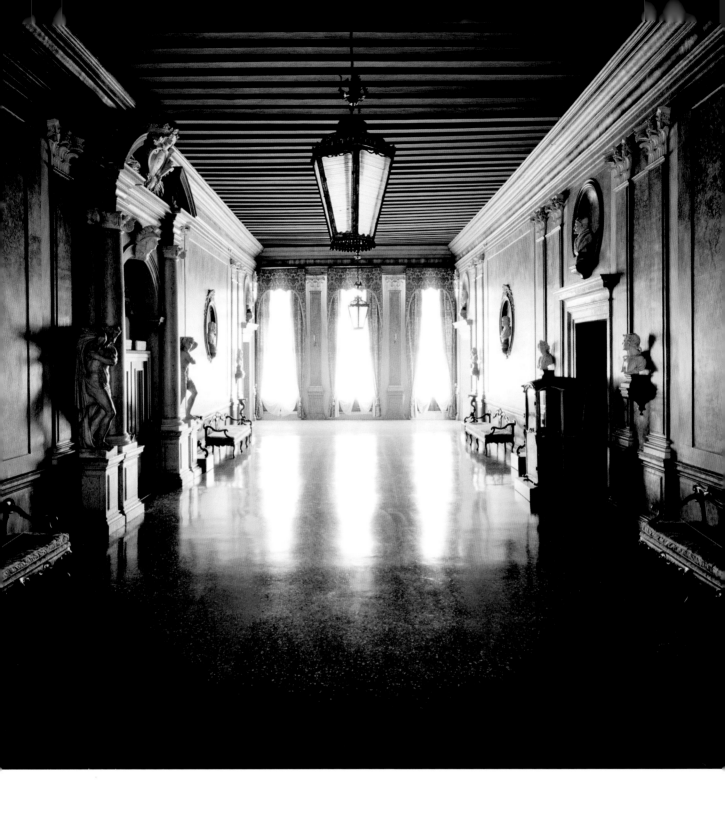

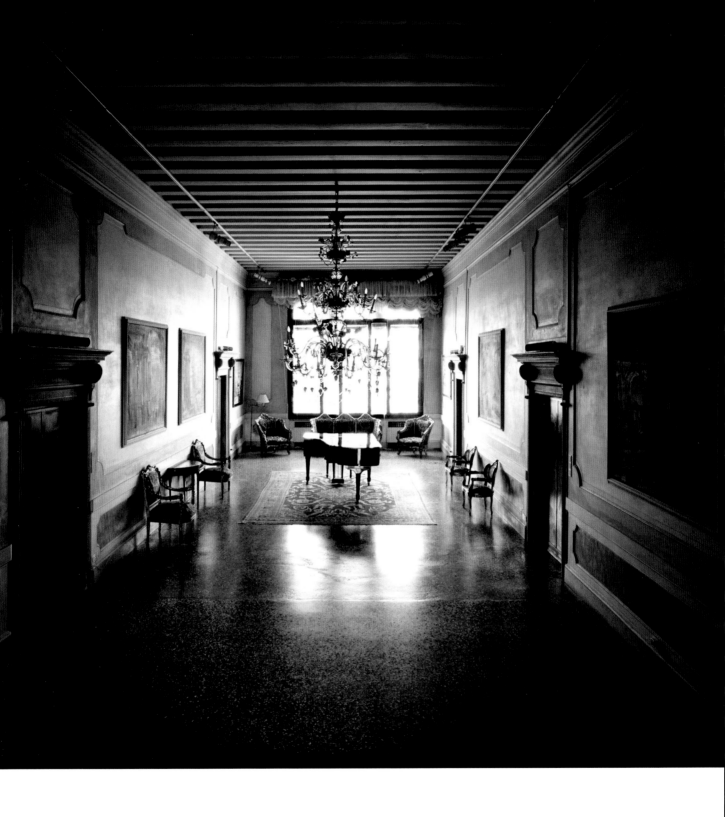

19

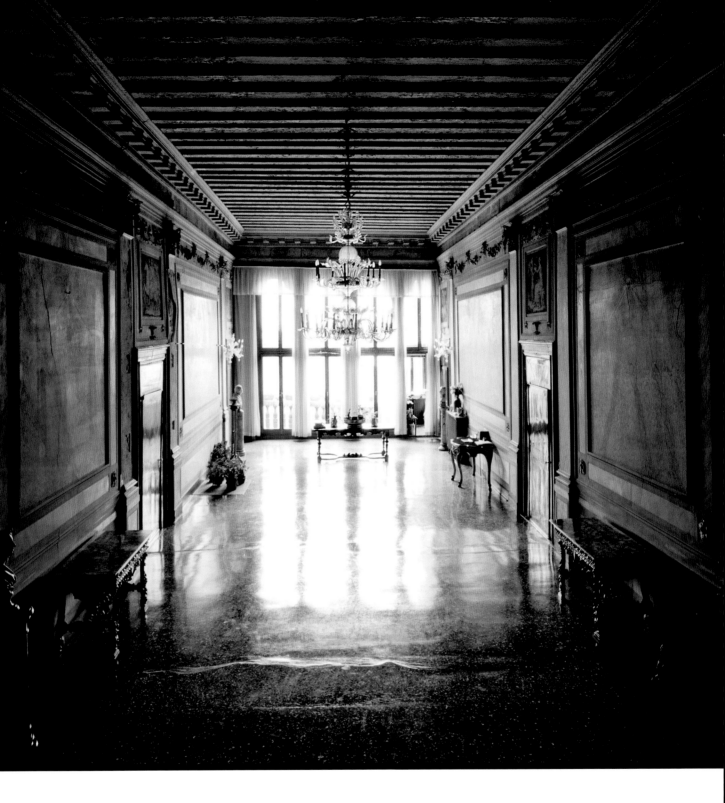

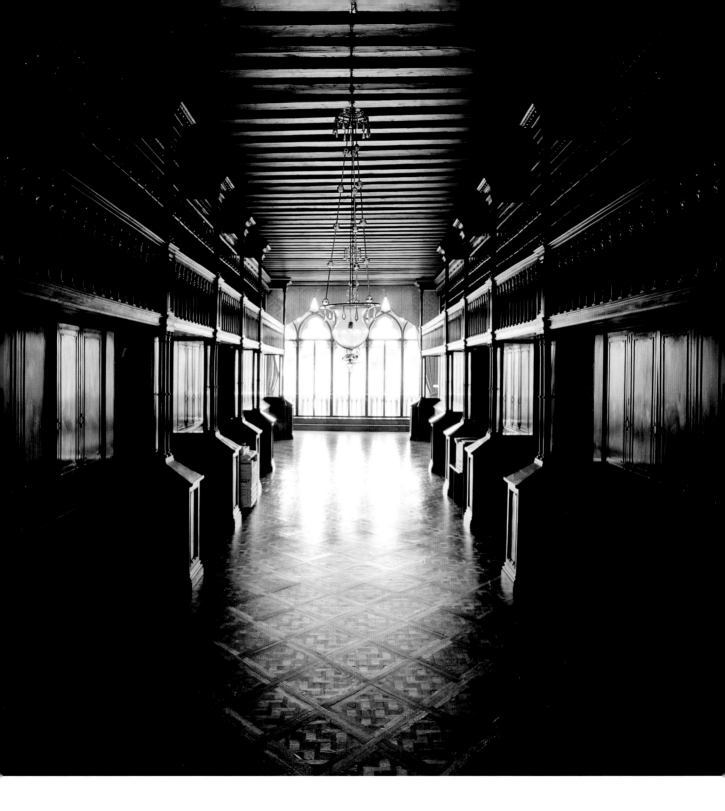

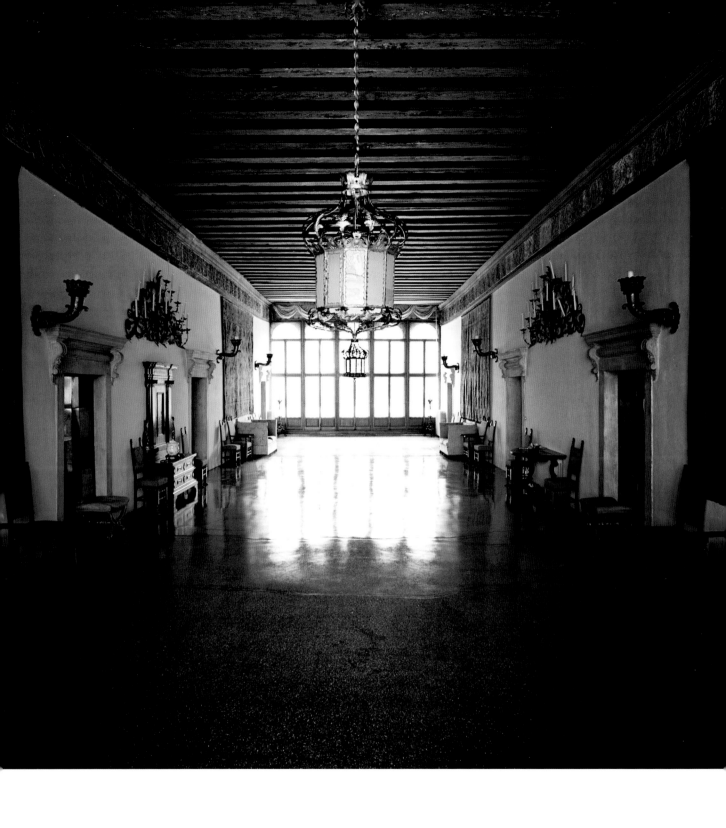

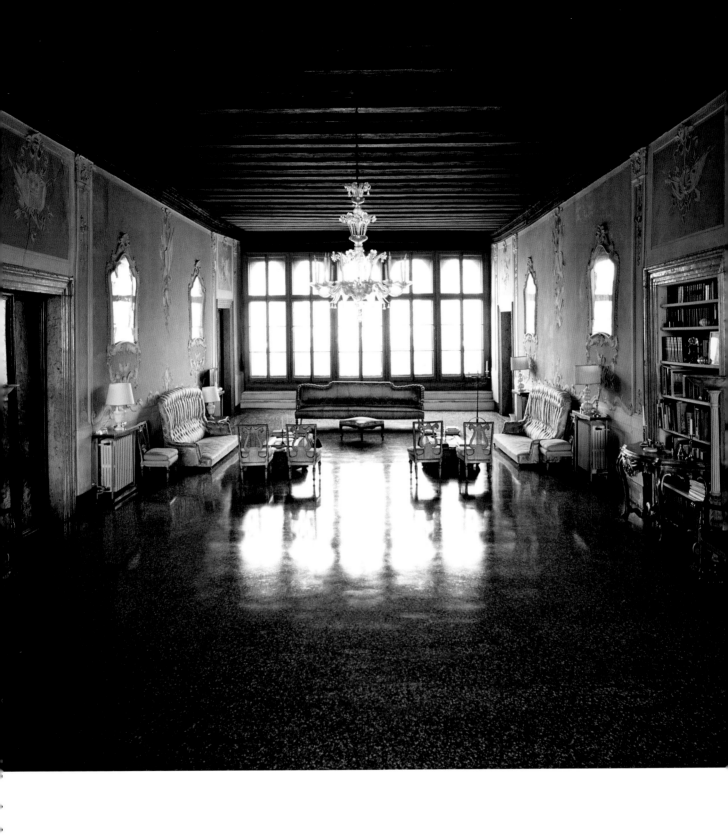

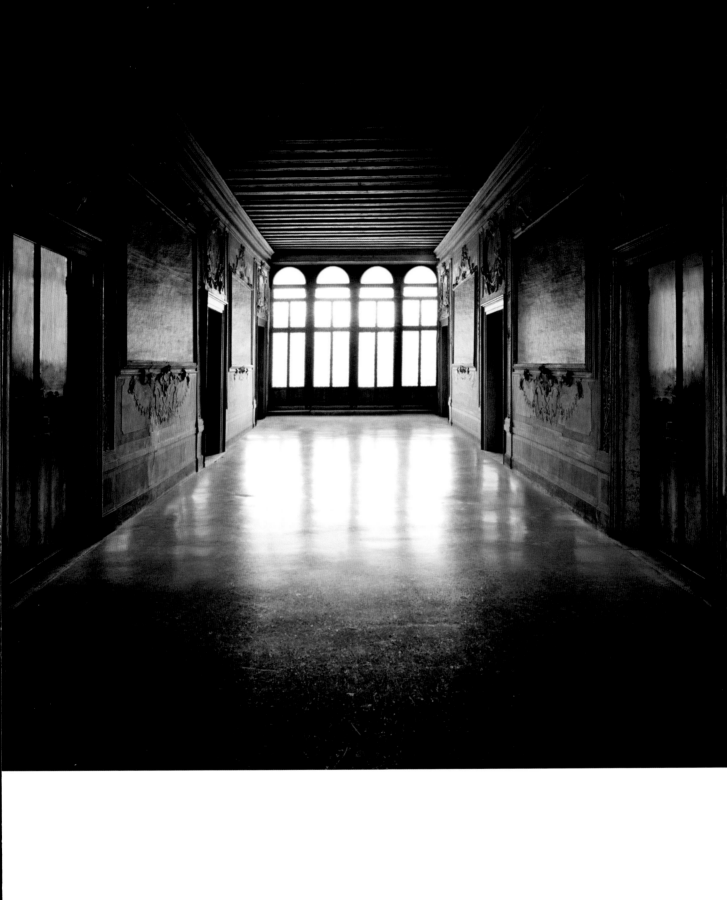

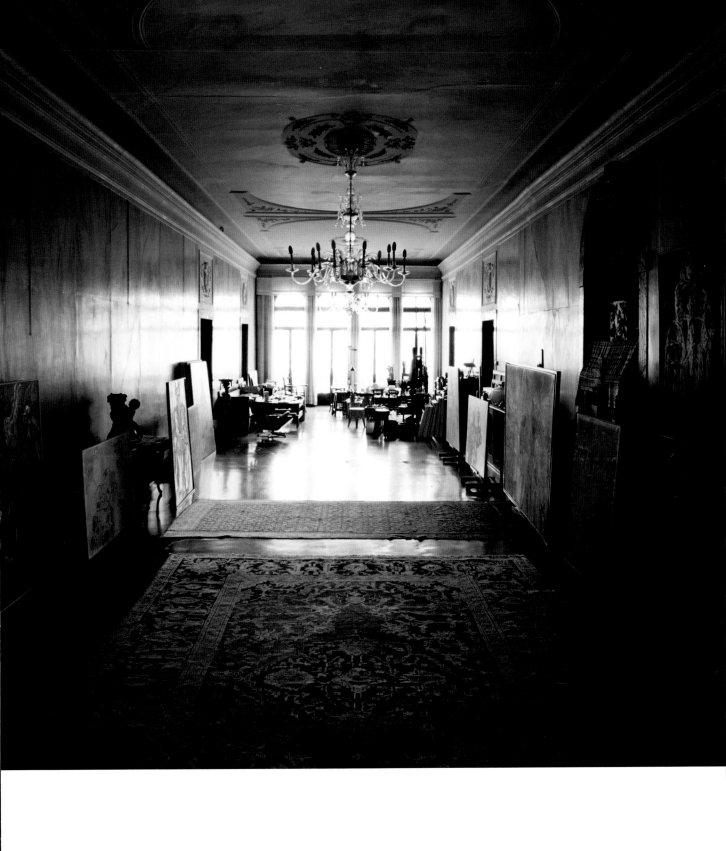

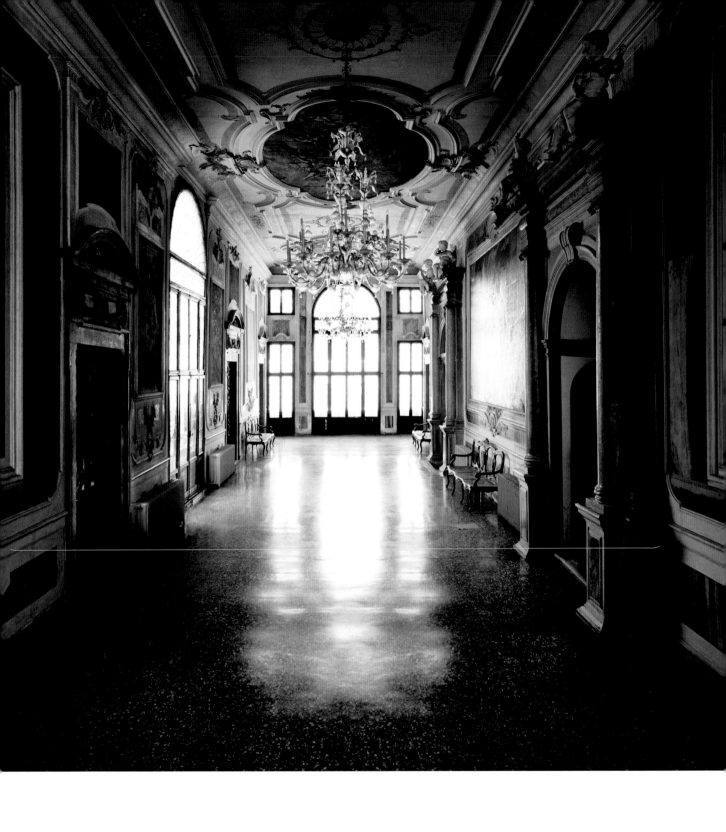

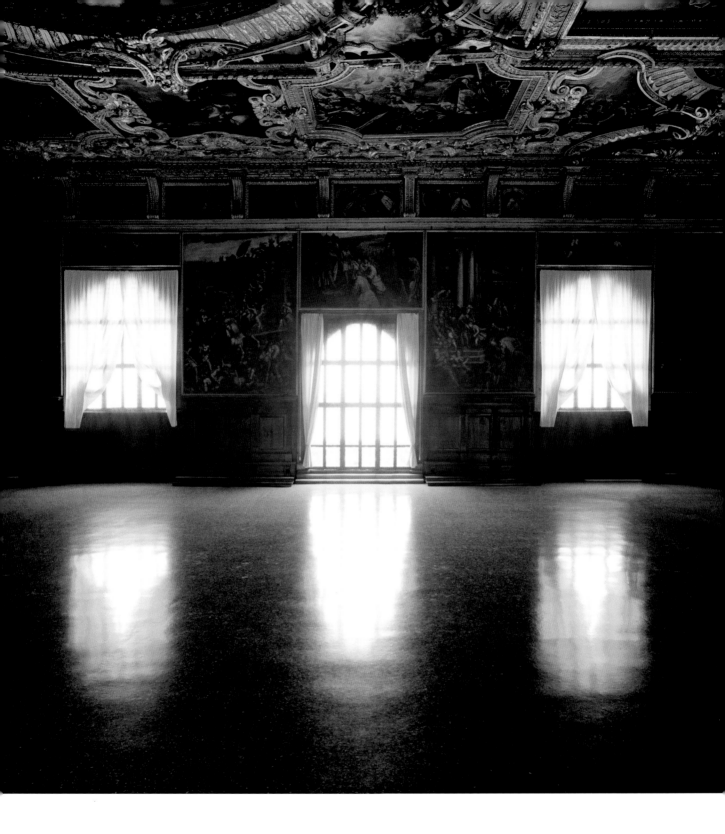

Solid Water, Liquid Stone

In the Palazzo Balbi the pavement is inside, traps light like honey keeps the
sweetness of bees, a frozen lake of space. The chandelier hangs in the dark well
of dusk, a deep sea squid suspended in liquid air. I almost cannot breathe, the
oxygen molecules are thick as treacle; I inhale dust motes, the damp dust of
centuries; tastes like chalk, must. The warm milk of the sun pours in through
the circular window high up in the Palazzo Giustinian Morosini, falling on a
wall where it exactly fills the empty space of an oval moulding.

This room; a corridor, a life. We walk along its cool length; stumble, run,
stagger, fall, pick ourselves up; sometimes saunter, strut or swagger, but always
reach the end – the *controfacciata*,[1] the space at the end of the corridor, the
beginning of the tunnel with the light at the end. The space between life and
death, between the darkness and the light beyond.

I am floating on the surface of the Grand Canal, I look up; the sky is full of
angels, billowing draperies, swirling putti, searing sunlight, sumptuous gold
brocade. Instead of clouds made of moisture I see ice-cream castles, solid
meringue masses, sometime they shift into the shape of faces or lions tumbling
in tundras, a mythopoeic melt-down, a cloudswell of metaphoric metaplasia.
Then I realise I am inside, it is not the Grand Canal in which I float but the
solid marble moat which separates this space from the façade. Solid water, liquid
stone. I let myself sink slowly into the marble, molecular fragments of malachite
sticking to my eyes. I seep through the first *piano nobile*,[2] then the next and finally
drift through the *androni*,[3] out through the *facciata*, and now I feel the sunlight
on my face, the soft feathering caress of dove wings, trying to wake me from
this dream.

This church of light, a sepulchre of silence, this rock of Venice into which is
carved the last resting place of the afternoon. There is an absence here; a Titian
once held the damp against this wall, flooded this room with brilliance, rolled in
the soft caress of sunlight like a child on a sandy beach, reached deep into our

eyes, clothed our retinas with golden fabric, glowing flesh, iridescent skies, laid low the darkness in this corner – which now returns. Blown and dimpled glass disks make a constellation of daytime stars on the filigree entablature of the plaster wall, a luminous tessellation of sunspots, a rich damask of sunlight, highlighting the recent restoration, rectangles of newly moulded stucco, like windowpanes of light.

There is majesty here. There is reverence too, the eyes of the windows look into the room, planishing the plaster with a sheen of sunlight, making dark doorways darker, doors which lead to other rooms, other lives. Or mirrors, doorways of a different kind, through the looking glass, into other worlds, other universes, other times. Are we surprised to find chairs here, children's toys, newspapers, televisions? Why? Is the tomb reserved only for the dead? Cannot the living live at death's door? Controfacciata? Emptiness is merely the absence of the familiar. These spaces are not empty but full. Full of light, full of history, full of dreaming.

I feel dizzy, fall gently to the floor. My eyelids, like camera shutters drenched in honey, close so slowly, open like butterfly wings, revealing a new world. Those ceiling beams become a procession of steps, a staircase leading to heaven; I rise, Lazarus-wise, walk at the pace of the dreaming, the dead, the one in love. The pace of one who hopes that the experience will not be over too soon, that somehow, by slowing down his progress he can make it last forever.

It is quiet now. It is soft and warm. The sun is padding shadows on my cheek, a cat's paw of heat. I am floating in a marble sea, the haze of light leaches into my eyes, I let my legs float to the surface, slide my back onto the skin of the sea, let my lids slip back; above me the oily trompe l'oeil of a Tiepolo.

The skin of the water is touching the skin of my lower lid; I sink slowly into the marble, it makes my chest ache, like slate sliding into the interstices of rib-space, I drift toward the controfacciata, an abandoned gondola, a dark swan pointed to the light, my death. The windows are gazing at me, opalescent with the late afternoon light. As the sun fades these eyes of windows blink once then fall

asleep. The palazzo is dreaming, The palazzo is dying. The city is falling into the water, falling asleep. When a city is sinking slowly into the sea, it is not necessarily dying; it may be becoming its own reflection.

Palazzo Volpi. There are red velvet chairs along the way, we may rest, stations of our crossing, places where we contemplate the inevitability of the end of our journey. I feel cold marble under the soles of my feet, my hair snags on damask wallpaper, fingertips stroking brocade on a chaise lounge, tongue cleaving to the roof of my mouth. Now I am afraid. I raise myself up one last time, my body moving like a leaden deep-sea diver. I move towards the Controfacciata, as if in a dream, a silent somnambulist. The journey along the piano nobile is the journey from birth to death; and thence once more into the light. I become weightless, float gently into the air, drift without volition toward the window, toward the light. In the piano nobile of the Palazzo Loredan stands a grand piano. Defying gravity, it floats on a magic carpet. The room is empty, no one plays, but I hear the music. It is faint at first, gradually it grows louder, filling the room with a polyphony of notes, cascading from the keyboard, rolling over the marble, a wave of sound.

Pestazzio, Mocenigo, Barbarigo, Farsetti, Franchetti, Pisani; these palazzi constitute the perfect camera lucida. *Light flooding darkness, paper holding shadows, patience making beauty. Welcome light, bright, into a darkened place, let my body seep, into paper's soft embrace, leave its trace; your art, steal my soul, fix it in your heart. The funerary gondolas ferrying their morbid cargo of rigor mortis tourists across the thin green skin of the Grand Canal. The plangent plash of vaporetto spumato masking the beat of my heart. Your face, haloed in the planished tangle of your golden hair, floating in the lapis lazuli light of the liquid air, follows me, everywhere.*

Are we one thing or another? Cannot we live in the special spaces, the intricate interstices, the fragile filigree of long past possibilities? Only one thing is inevitable: our progress along this piano nobile, out of darkness into the light, across this skin of refractive matter, this lake of stone, this marble meniscus, to the glass-thin skin that separates us from eternity.

We always run the last few yards, into the controfacciata, leaping into the haze of light, rays of sunspoil etching our body like a blowtorch turned on a worm, a shattered spangle of broken glass haloing our fragmenting form like a mantle of ruby raindrops shadowing a dog on a rainy day, our body shivering and sparkling into the aquamarine air above the Grand Canal. Everything stops for an instant. We spin in space, yet remain in the same place. Our eyes face in every direction at the same moment. We have arrived at the end, and also at the beginning. The water lies beneath us, the sky above, the space around. When gravity pulls its final card, we plunge, Icarus-winged through cirrus cloudbanks into the blue lucent depths, the icy clasp, the chill embrace. Instead of trying to breathe, we open our lips, our mouth, welcoming in the water, it fills our lungs like frozen gin, like olive oil; soft, smooth, cloying.

The light is coming; it is almost time. We wait. Just before the moment, the second when the piano nobile will be full of effulgent luminosity, the hour hand of the watch kissing the five, the perfect blush of sun on marble, wood and plaster, before the shutter's succulent click; I leave. Walk away from my death, out into the air, onto the steps at the back of the palazzo, let my gaze tangle around the twisted vine outside which strangles the rusting iron banister, rough bark chafing my skin, tasting my blood, staining my name into the palazzo, I leave part of myself here.

Matthias Schaller digitally drains his large format photographs of colour, a mimetic device that echoes the etiolation of the complexion of a corpse. This evocation of deathliness relates to three different referents. The deathliness associated with Venice as a city, slowly sinking into the sea, gradually being abandoned by its population, a city frozen in the *Quattrocento*, re-populated with tourists and preserved in a museological aspic of time. The second is the condition of the palazzi themselves; many abandoned, crumbling, boarded-up for decades; repositories of the memory of families long departed, the empty piano nobile and androni gradually liquefying in the crystal light. Lastly we

speak of the deathliness of photography itself. Once a photograph has been taken its original referent is metaphorically 'killed' – as in the belief-systems of so-called 'primitive' tribes, who did not want to have their photographs taken for fear that their soul would be stolen – the signified sacrificed to the eternity of the signifier. The image now holds the life of the original in an eternal and deathly embrace. It is because photography fixes an instant in time that holds the clue to its ability to evidence the mortality of the subject.

Here the subject is not a person but a building, and moreover, the interior of a building. The interiority metonymically evokes the notion of the building as being, the piano nobile is the head, the windows the eyes that gaze out at the world but also inwards; observing the observer. These extraordinary spaces, tunnels of life and death, are full of the eidolon of its past inhabitants. Their revenants haunt the space like unspoken sentences, felt, but never uttered, thought, but never given voice. The anomaly of the few photographs that depict palazzi that are still inhabited – *Palazzo Mocenigo* (2004) for instance – only serves to reinforce the emptiness of the majority of these spaces. If anything, the ciphers of human habitation in these funereal and abandoned 'corridors' serve to emphasise their barrenness.

Artists have always been attracted to Venice, both as a place to live and as a subject. Monet's series of paintings from 1908, which included *The Doge's Palace*, *The Palazzo da Mula* and especially the *Palazzo Contarini Polignac*; Turner's views of palazzi from the Academia bridge; Matisse's paintings of palazzi reflected in the Grand Canal; and today Schaller's reversal of this conventional 'pictorial' representation of that most picturesque city presents a very different aspect of that waking dream we call Venice – the grand palazzi, inside-out.

Outside there is the constant and dynamic ebb and flow of the water, it does not just surround the city, the water *is* Venice; dappled reflections on the walls and the ceiling of the piano nobile bring the water inside turning the interior into a quasi exterior, this is reinforced by the marble floors, literally *pavimento* in Italian. These polished expanses function as a sort of interior canal, echoing the liquid

world on the other side of the controfacciata. There is a constant but quiet battle between the city and the sea, the sea will win; but for the moment the windows of the palazzo watch as the green water licks at its sunken stones, a deadly caress, as the damp rises slowly to its eyes.

RICHARD DYER

1 Literally the 'counter-façade', the area of the first floor immediately behind the outer wall.

2 First floor, often the second floor is also called the piano nobile.

3 The ground floor, giving onto the water, usually of the Grand Canal.

I am grateful to Barbara and Tonci Foscari, Ben Brown, Lia Rumma,
Lorena Ruiz de Villa, Bianca Arrivabene, Alejandro Suarez,
Elisabetta Cipriani, Magdalena Ghi, Montserrat Llaurado, Gerhard Steidl
and to those who opened their doors for me.

MATTHIAS SCHALLER

Matthias Schaller was born in Dillingen/ Donau, Germany in 1965
and studied Cultural Anthropology. Solo exhibitions: "Kult im Bild",
Diözesanmuseum Rottenburg (2000), "Studio Gursky", Goethe
Institute, New York City (2001), "Werkbildnis", Biennale di Architettura,
Venice (2002), "Matthias Schaller 2000–2005", Art Basel, Miami
(2005). He received the 2004 Ci Art Award. Schaller lives in Venice
and New York City.

The series was executed between Ponte di Rialto and Piazza San Marco in Venice from 2004–2007.

C-print, mounted on aluminium, plexiglass, wooden frame,
signed, titled and dated on reverse
print 180 × 180 cm (70⅞ × 70⅞ in), image 165 × 165 cm (65 × 65 in)
edition of 6 plus 1 AP

Published on the occasion of the exhibition
Matthias Schaller *Controfacciata*
at Ben Brown Fine Arts 6 February – 20 March 2008

Ben Brown Fine Arts

21 Cork Street
London W1S 3LZ
Tel. +44 207 734 8888
Fax +44 207 734 8892
info@benbrownfinearts.com
www.benbrownfinearts.com

First edition 2008

Images © 2008 Matthias Schaller
Text © 2008 Richard Dyer

Catalogue © 2008 Ben Brown Fine Arts, London
and Steidl Publishers, Göttingen

Design: Peter Willberg, London
Scans: Arrigo Ghi, Modena
Production and printing: Steidl, Göttingen

ISBN 978-3-86521-674-8
Printed in Germany

Steidl

Düstere Straße 4
D-37073 Göttingen
Tel. +49 551 49 60 60
Fax +49 551 49 60 649
mail@steidl.de
www.steidlville.com / www.steidl.de